migraré

migraré

Darrell Bourque

paintings by Bill Gingles

UNIVERSITY OF LOUISIANA AT LAFAYETTE PRESS

2019

Front cover image: *High-level Goings-on*, 54" x 44," Acrylic on canvas

ISBN 13 (paper): 978-1-946160-52-2

http://ulpress.org
University of Louisiana at Lafayette Press
P.O. Box 43558
Lafayette, LA 70504-3558

Printed on acid-free paper in the United States
Library of Congress Cataloging-in-Publication Data

Names: Bourque, Darrell, author. | Gingles, Bill, 1958- illustrator.
Title: Migraré / ghazals by Darrell Bourque ; paintings by Bill Gingles.
Description: Lafayette : University of Louisiana at Lafayette Press, 2019.
Identifiers: LCCN 2019032087 | ISBN 9781946160522 (paperback)
Classification: LCC PS3602.O89275 A6 2019 | DDC 811/.6--dc23
LC record available at https://lccn.loc.gov/2019032087

for Karen

for
my children
and grandchildren
and for all those
they love

and for all
who walk into
the border of
difference
and
are unjustly
denied
passage

FOREWORD

Ghazal?

In this set of ghazals I do not attempt to adhere strictly to any of the prescriptives of the ancient forms or the dominant practices in more contemporary variations. The rhyming in these poems varies from poem to poem, and rhyme is informed by the old dictates but not bound by them. The dominant rhyme pattern in these ghazals is a pattern in which the closing words of the first and second line of each couplet rhyme. However, in some of the poems freer and more varied rhyming patterns are used. Like in the traditional ghazal, I let the number of couplets range from the usual 5 to 15 couplet practice, and the couplets are linked together as beads on a string, related associatively to theme but not constituting a strict narrative. That is not to say that there are not narrative elements in these poems. Rather than the strict metrics of the ancient Arabic form, my lines are more in line with the contemporary, other-than-Arabic-language-practice, of making the lines of the couplets of generally equal length. Also, rather than building the poem around the repetition of the last word in the first couplet, these ghazals are titled as the paintings they are keyed to and the entire title of the painting is repeated in most of the closing words of each couplet.

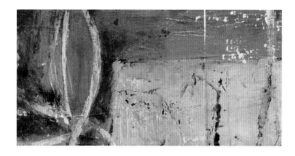

Ekphrasis?

The practice of ekphrasis dates as far back as Homer in Western literature and surely there are evidences of the practice in other parts of the world as well. The traditional practice takes the "skin" of a piece of visual art and builds a poem around the images in the work. In Homer, the ekphrastic poem is a description of the shield of Achilles in *The Iliad*. This set of ghazals attempts to extend the practice. The poems are not retelling or re-contextualizing or creating a narrative from the images in the visual work. These poems build around the tensions, composition, line, color, and the theater created in abstract expressionistic artworks by one particular artist—Bill Gingles, of Shreveport, Louisiana. The poems are *keyed* to the paintings rather than extrapolated from them. The result is often a musical relationship rather than a visual-lexical one.

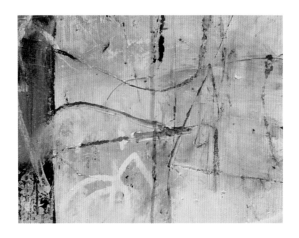

migraré?

The Spanish *migraré* ("I will move") and the related Latin and Italian *migrare* ("to move into") are the armatures these poems build themselves around. The poems also play against an observation in Toni Morrison's 2009 Oberlin College convocation address, "Home," where she points out that "the reconfiguration of political and economic alliances and the almost instant reparsing of nation-states encourage and repel the relocation of large numbers of peoples. Excluding the height of the slave trade, the mass movement of peoples is greater now than it has ever been" ("The Foreigners Home," *The Source of Self-Regard*, p. 18). In the last ten years since that Morrison report, that "mass movement of peoples" is even greater.

What to do with peoples propelled by "I will move"? What happens in the theater of place as more people see not only options of betterment but the very option of survival leading them "to move into" places other than the place they once called home? What happens with new definitions of home for those moving and those whose "homes" are being moved into? What happens to identities and environments when these movements occur? What are the components of violence attached to "I will move" and "to move into"? And, where does faith and hope lie in the mix of the mass movements we are experiencing?

Throughout human history one of the great challenges has been what to do with the "outsider" or the "stranger" who "moves into" a new place. I am interested in the idea as it applies to contemporary civilizations, contemporary nations, contemporary migrations that trouble us so. In the most ancient times, it was not unheard of for the stranger or the other or the outsider to be killed. The act of "moving into" was dangerous and life-threatening. In later times, some saw the stranger or the outsider as a messenger or a carrier of the divine and that person was treated with care, with reverence, or with a sense of celebration *because* this Other had moved into the sphere of the receptor.

It seems to me that those remnants of old cultures still operate in us as we are making our early moves into the twenty-first century. It also interests me that "moving into" is as natural and as timeless as anything humans can experience. Biologically we move into the world from some other world. We move into this world through the narrow passageway of a birth canal and the passage can be as dangerous as it is miraculous. We are creatures of environments and beings moving into each other in every way imaginable. And, we are creatures of territories and of boundaries. We link our notions of rights to relationships built around ownership of things we often cannot rightfully, or in any other way, possess. We construct identities and ideas and practices of dominion and domination around vocabularies that contain words like *alien, native, refugee, citizen, migrant, immigrant,* often with calcified, even intractable, ideas about *us* and *them*. These ghazals are an attempt to "move into" the experiences of the Other so that we might begin to see each other more clearly, more justly, more humanely; see each other as occupants of place, respectful of difference, diversity,

tribe, roots, clan, and race, but more so, respectful of the over-riding commonality of Being and the inherent Rights of Being; that we might see the truth in the lines of American First Nation poet, Joy Harjo (*Conflict Resolution for Holy Beings*, p. 24):

> *This is only one of many worlds. Worlds are beings, each with their own themes, rules, and ways of doing.*

It is my hope that readers see in these poems their own histories. That my Acadian readers take in the poems with a mindfulness of their own ancestors' forced migrations, first from France, then their experiences of exile from Acadie. That they recall the repulsion Acadians experienced from all attempts at acceptance, then and in the centuries that followed. And finally, that they remember the closed borders and non-admittance they faced all along the Atlantic Seaboard in colonial America with their numbers diminishing and the people on their boats starving and dying before they made their way to New Orleans, and finally into *Acadie sud*.

It is also my hope that other American readers see their own obvious immigrant histories or remnants of their histories in these ghazals, and that we also see that these poems are about the ways we create "immigrant" populations in our own country: how Jim Crow laws created a whole new immigrant population of the newly freed slaves in the United States in the nineteenth century; how the effects of those migratory experiences still diminish us; how poverty and class create Other populations; how racism is another form of wall building; how LGBTQ citizens have experienced an Other American experience. The idea of Other is pervasive, insidious, and ubiquitous. It knows no particular geography or culture or people or history or ancestry. We must be ever vigilant not to separate ourselves from each other in destructive and debilitating ways. We must be vigilant in how this story of peoples moved and being moved

tragically and differently unfolds in the stories of slave trades of any kind, especially the slave history of Colonial Europe, Africa, and America. We must be equally vigilant of how this movement story, and who moves who where and who forces people to stay where, plays out in the history of the First Nations peoples of the Americas.

If a Kurd, or a Moroccan, or an Algerian, or an Iranian, or an African, or a Palestinian, or an Israeli, or Vietnamese, or Korean, or a descendant of the Japanese internment camps should ever read these ghazals, it is my hope that they too read a remnant of their own histories, hear in them some phrasing or record of their own lives.

Darrell Bourque
upon completion of *migraré*,
January 2019

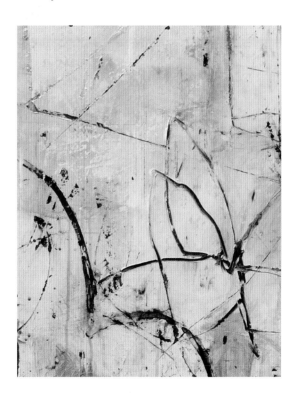

Details from *High-level Goings-on*, 54" x 44," Acrylic on canvas

THE BRACELET UNDER THE OAKS IN SANJAY AND KEVIN'S YARD

Preamble:
a ghazal for Faisal Mohyuddin

The dancers were waiting for us.
They were dancing under the oak trees.

The oak trees were in Sanjay and Kevin's yard.
In Sanjay and Kevin's yard the dancers were barely moving.

They were barely moving in a circle.
In the circle three men sang.

Three men sang to a butterfly moving
& lighting on the resurrection fern,

the resurrection fern growing in the air on the oak's limb.
The oak's limb danced from the trunk.

From the trunk the limb almost touched our dancing heads.
The limb almost touched us. We moved in a circle.

In the circle we were barely dancing.
We were barely dancing & the woman of the yellow shawl

on her arm danced with a fan of turkey feathers.
A fan of turkey feathers danced for turkey feathers.

Turkey feathers danced with the gar fish
scales hanging on young Cidney's ears.

Young Cidney's ears danced to heart beats
in Faisal's chest. Faisal gave his chest

to Colum & Lisa. Colum & Lisa danced
with Karen who danced with Alex on the other side.

On the other side Lily danced with an elder woman.
An elder woman danced with Alex too & with Felice

& Felice danced with Michael & Samantha & Rob
danced with Hillary & Malak & Genti & Bayard

& Bayard danced in a circle with his son Jackson
& we were all sons & daughters moving,

sons & daughters moving us into the darling world
we move inside of, the darling world we pass through.

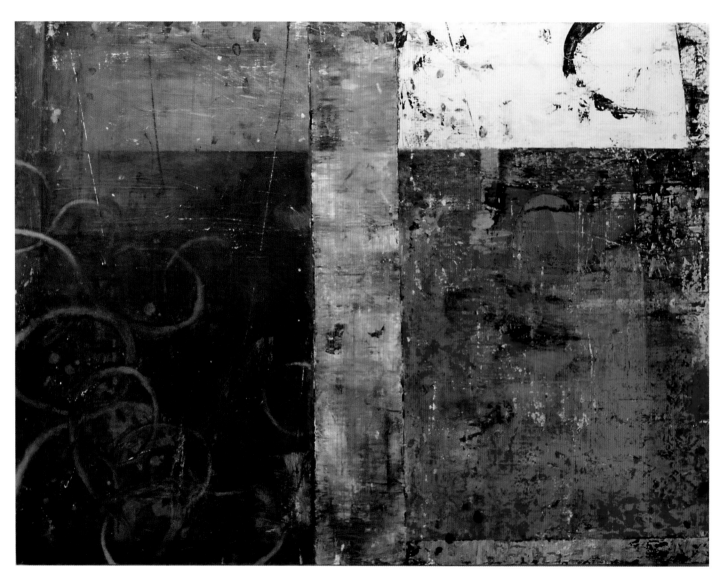

Division Stream, 30" x 40," Acrylic on canvas

DIVISION STREAM

My great grandmother's first lesson in separation was separation of milk and cream,
milk a delicate blue tint, cream a pearly yellow, in-between invisible division stream.

Her separations turned to clabbers and soft cheeses spread on biscuits in the morning,
with mayhaw jellies and blackberries she picked while praying into the division stream.

She arrived one day with a small satchel and all her belongings and with no husband.
What took him from her she couldn't even begin to know. Death's a division stream

untranslatable in some languages. When great imperceptibles come to live with you
and you cannot travel far enough to get away, you swim daily in your division stream.

You try not to drown, your feet reaching for something like ground but never finding it.
She prayed aloud, some prayers like poems. I fell for remainders in that division stream.

She was all French and I was all something else. She couldn't wrap her tongue around
my name and we couldn't tell who held who when we went past our division streams.

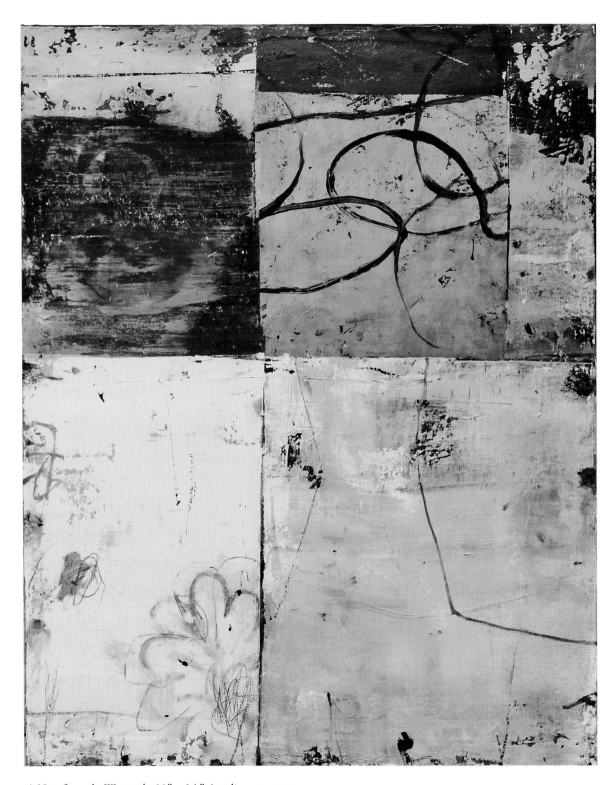

A Note from the Waterside, 30" x 24," Acrylic on canvas

A NOTE FROM THE WATERSIDE
for Gregory Khalil

You say those songs you're always singing are only notes with no place to hide
until a tune you've sung a thousand times gives you a note from the waterside.

In a flurry of faces from across the room your beloved in some blue transparency
appears and the world is all fishes and flowers coming at you from another side.

You want to plant whole gardens filled with gingers and irises and altheas,
all white to go with the roses climbing through that note from the waterside.

Iris DeMent is singing Reverend McGee's version of Buffum's old-time hymn
about fifty miles of elbow room. You see the gates are wide on the other side.

You stitch the ground with your walk. The beloved is the mystery you live in
now. You are not who you were before you got the note from the waterside.

You hear Reverend Barnes sing about the other shore and no more weeping
and no more crying and you believe for sure there is belief on the other side.

You plant parsley when the ground is warm enough to plant parsley and sage.
You became a gardener on the day you began to see the way to the other side.

Blessed Hanh leads the young monk in morning recitations of The Heart Sutra.
Insight is attainable. It's one way to the gone, gone, gone over on the waterside.

No line is accidental, no movement is transgression here. Luma is the physics here,
the blue equations in Lorca's songs, all the unknowns in notes from the waterside.

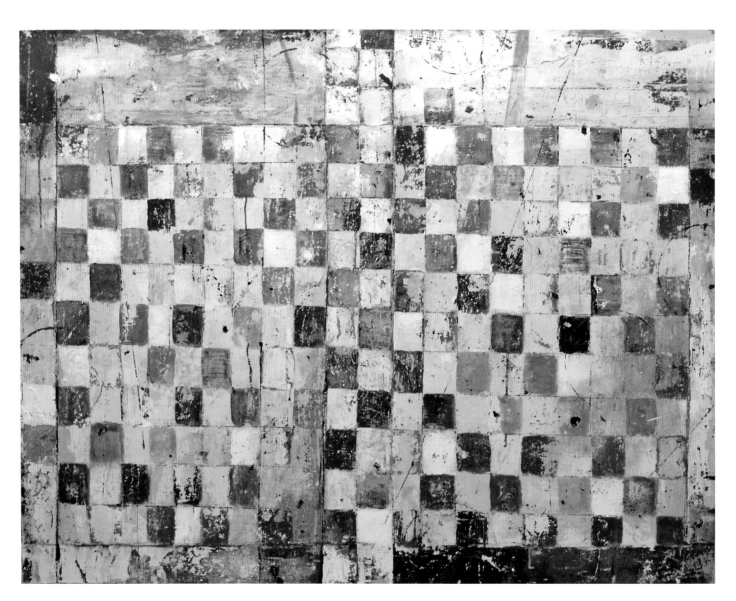

Maya, 40" x 52," Acrylic on canvas

MAYA

for the tillerman

The world is made of blocks and shadows, of lines and curves the old people called *falaya,* each block a world, each world a river to someplace else. If you doubt it, just call up maya.

Moonshadow? Funny, that was in Spain … I went there alone … I was dancin' on the rocks …where the waves were, like, blowin' and splashin'. Rocks, water, dancing Stevens, maya.

Try playing hopscotch. It could be a numbers game, or a balancing act, or a precision toss, or turning design inside out or spin or it could be all those things. Or maya dreaming maya.

So you take those words and just let them go whichever way they want … Moonshadow? Playa. Put one block next to another, change your name, it changes everything. Ask maya.

Something in him never changed. He's still Steven Demetre Georgiou. He's still Yusef Islam and the Yusef without, still the man who pals around with Dolly and her ghost sister, Maya.

So, Bourque, Bourg, Darrell, Lhakthong, Jude, Ambrose, Luma, you're all one and the same and none of the same. Write two poems. One speaks true, the other dances with maya.

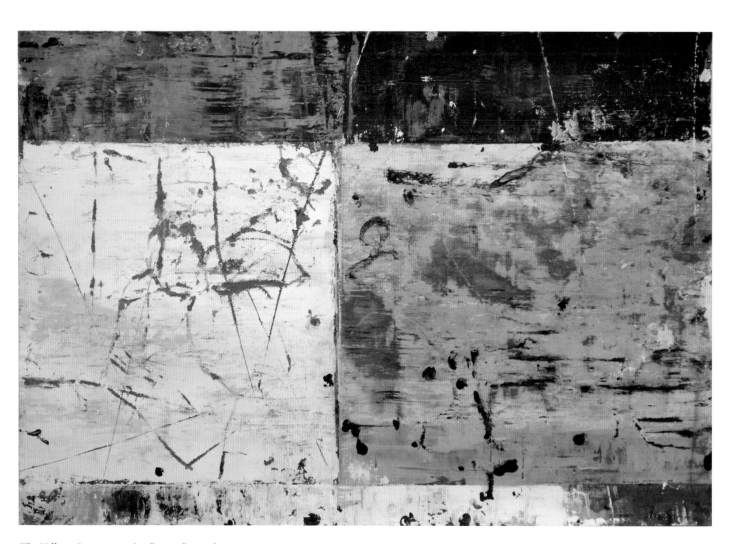

The Yellow Covenant, 14 ½" x 21," Acrylic on paper

THE YELLOW COVENANT

Rumi met Shams. In the square transfiguration. Nothing loud here among the penitent.
Books in water, or burned, a disquisition on a donkey maybe, then the yellow covenant.

That it is darkest just before the light of dawn is just not true. Nothing is as uncertain
as an easy saying. Ask any early riser of pilgrimages on his way to the yellow covenant.

Flowers you don't see in the white light of noon or in the middle of the night are there.
They don't need you as you need them as they need the sun inside the yellow covenant.

In the theater 5 can be a magic number, or 3, or the play is all serial and sequence opera
ruled over by Gertrude Stein, no there there here, actors, lines from the yellow covenant.

The mystic forgets the given name or hangs little on it, can carry his names in a coin purse.
Loss of names is not the loss of everything. The sun names nothing in the yellow covenant.

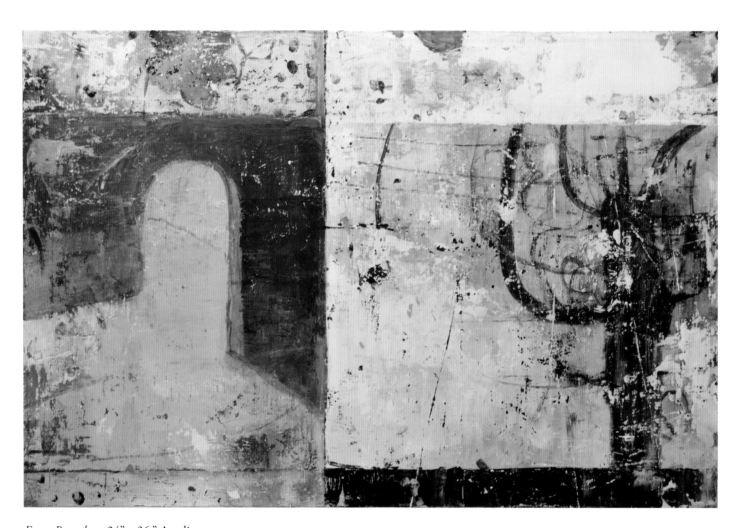

Event Boundary, 24" x 36," Acrylic on canvas

EVENT BOUNDARY

Mystics working on bells mostly just work on bells. The life inside the foundry
is life inside a foundry. Days are unlined and hours unmarked by event boundary.

That yellow wall with arched doorway is a yellow wall with an arched doorway.
One street might lead to the arch, another not. A street is not always boundary.

Something that looks like veins of lapis lazuli in bedrock could be purple flowers,
Édith Piaf's grave in Cimetière du Père Lachaise, bird song, a sparrow boundary.

We call dusky blue watery flowers in southern gardens hydrangeas, like those
in yards on Desire. The blue is della Robbia blue or edge of madness boundary.

That dark road you've traveled on some nights can take on light if you stay with it.
Travel east to west or west to east, forget knowing, cross the unmarked boundary.

Mystics, and poets, and fools often forget their names or answer to any name,
or do not answer at all. Too few names stick. Few words rhyme with boundary.

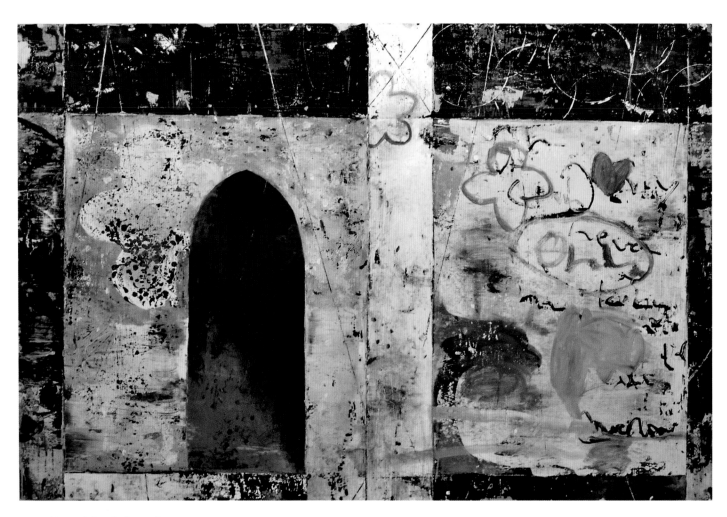

Every Time, 40" x 60," Acrylic on canvas

EVERY TIME

for Caroline Ancelet

Every time she walked near the channel of water she heard a silver rhyme.
Mint, fennel, tarragon, and thyme sing green in running water. Every time

she walked through the dark arched opening, she reached for the handle
to the inner door into her garden. Light there was her light. Every time

she trimmed and hooked branches of the fruit trees to the garden wall,
she prayed the prayer of bending branches and holding on. Every time

she carried figs and pomegranates or pears into the house, she brought
enough for everyone she cooked for and she brought in extra every time

for jams she'd make to give away to her old friend down the street,
to those who visited her. She put out jam and flat breads every time

she thought someone was at the gate. The jam glistened like jewels,
the tea was hot and sweet. She put out oranges and limes every time.

She knew walls that separated her people from her people. She knew
walls to weaken her. She walked away from them stronger every time.

That name in a Beatles' song from across the wall, it's all our names.
All us Jules taking a sad song and making it better. It helps every time.

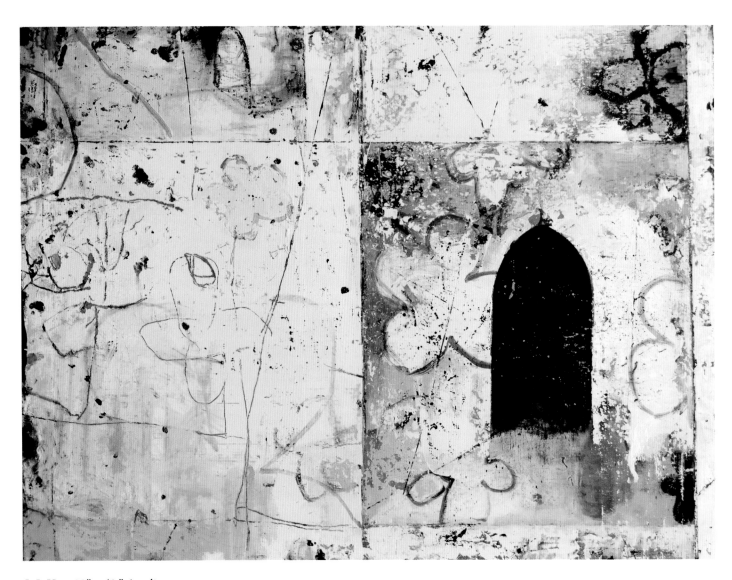

It Is Here, 30" x 40," Acrylic on canvas

IT IS HERE
for Cindy Barry

Tinges of the blue Mediterranean are everywhere the eye goes in old Tangier.
Matisse blue is part French, more than a little African. It is blue singing *it is here*.

The nights there are deepest blue until midnight. Then maybe no one cares
about sky after that. You cross the door to Africa. It's why you traveled here.

At mid-morning the souk is the souk open for business. Beyond that dark arch
dark coffee, *cornes de gazelle*, orange blossom water. You are being born here.

Sargent's *Fumée d'ambre gris* studies white on white. His Moroccan street scenes
even disarmed an often stately Henry James. Bear it. Beauty marries memory here.

All day you are eating dates. In your stories, your poems, paintings, songs, you eating
ghoriba, smoking, whitewashed walls, everything blue inside you humming *it is here*.

As of today no god has called to me, no Bourque call testing, waiting for an answer
and a following but if one calls, I'll know just what to say. *I am here. Lord, I am here.*

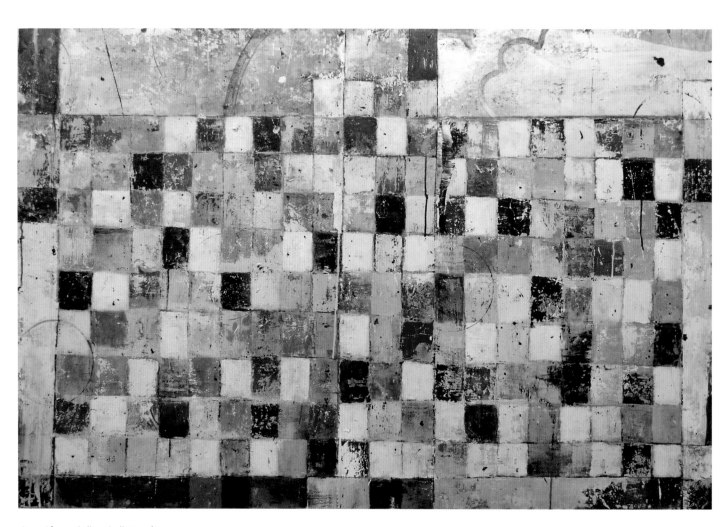

Sun Choir, 40" x 60," Acrylic on canvas

SUN CHOIR

for the Christ the King-Bellevue Choir

Our choir leader Betty Malbrough knows all about how that fat gets in the fire.
She sings trouble over trouble every Sunday at Christ the King in her sun choir.

Some ladies sing with hands. Some move their shoulders, one shoulder higher
than the other in doo-wop sway. Brother Wilfred's the bass line in this sun choir.

Even when the priest is late, Betty's right on time. *My hands up, I burn like fire /
Float up to heaven like the smoke in the air.* Her hands, like a dove in a sun choir.

All in my house / All in my house, Authurine dances to a little light, a gentle fire.
Out in the dark / Oh, out in the dark, Virginia brings alto light into our sun choir.

Here as everywhere are grave reminders. Dark squares, prior, latter, sinner, friar,
faint flowers, small plots of sacred nothing, those too are sung to by the sun choir.

I sit in one of the back rows with my wife, near Henry Amos. We couldn't be higher.
There are no names on pews here. I hum. My wife sings out. It, too, is her sun choir.

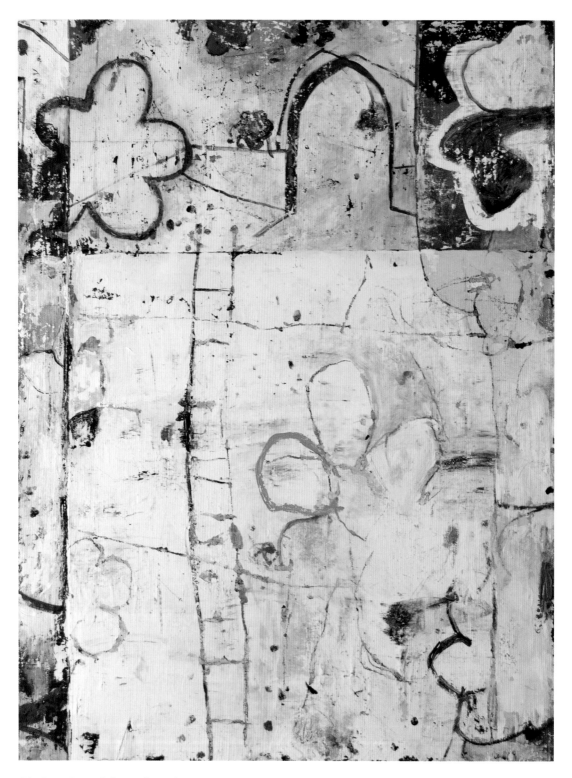

The Same Story, 40" x 30," Acrylic on canvas

THE SAME STORY

The story of the movement into another world. The Latins had a word for it, *migrare.*
How you began your journey in a canal no one thought could hold you, the same story.

The ladder dreamed about for ages, one with angels going and coming, Jacob's story.
Jacob wrestles angel, Jacob limps, Jacob leaves home, his and yours, the same story.

In hot climates all over the world people sleep on roofs, pueblo under the stars story.
A pueblo under the stars story is a people or town story. It is to some the same story.

Rosemary and nightshade edibles might be part of any grandmother's garden story.
In Croatia, in Sardinia, in Abiquiú, in Arnaudville, grandmother cooks, the same story.

The sunflowers in Arles, irises, postman, crows, wheat, olive groves, Van Gogh's story.
The blue bedroom with its little yellow bed, the turning self, all part of the same story.

Arches in churches, arches in flowers, arches the night sky makes, every arched story
you've ever entered takes you other places, moves you around inside the same story.

Italo Calvino takes us along to 55 cities named for women. It is his invisible cities story.
In the opera version the train station it was set in was operational. It's the same story.

Charles Bolden fell out that day everything turned white hot. Jackson's but one story.
He played and then he didn't. It was jail then transfer to the Asylum, the same story.

I once got lost in Florence outside the walls of the old city. My Carmelite convent story,
Antibes story, Santa Fe story. My name is of no use in them. They are all the same story.

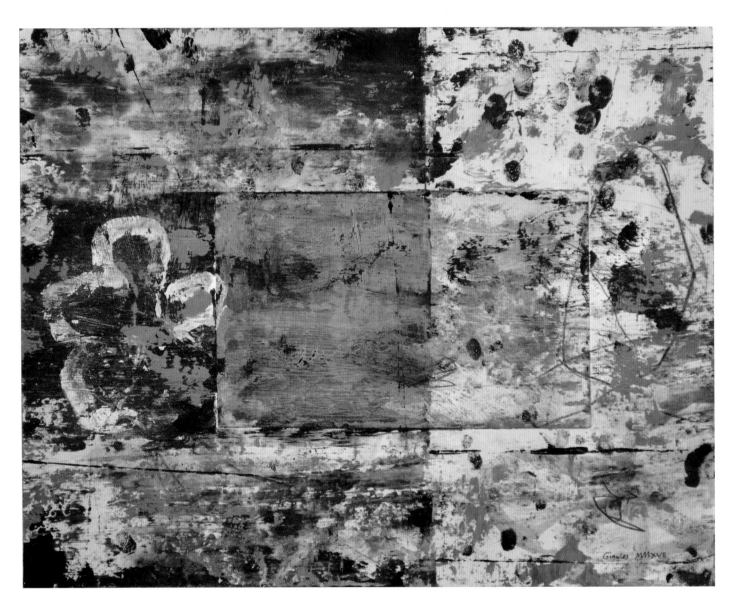

Today + Everything, 11" x 14," Acrylic on paper

TODAY + EVERYTHING

Courbet took his palette from the world he wanted to see. That flock of starlings,
the mourners at Ornans, his murmuration of grays and dun, his today + everything.

The pilgrims move counter-clockwise around the Kaaba. They make the sacred ring
of pilgrims in pilgrimage. Dress, wash, cut hair, stone evil, circle today + everything.

Before rice fields are tender greens, or gold, or filled with grain, or songs we sing,
they're mudflats. Gueydan, Crowley, Kaplan, Egan, singular place today + everything.

The Creator made a whole world under water. Chitimacha suggested a mound offering.
Creator had crawfish pull first mud from water. Red man rising + today + everything.

Courbet painted what he saw. Two red clerics above the grave are not meant to bring
color to the scene. They were just there at the funeral + death + today + everything.

There's red in black, blue in blackbirds. Monks in browns, grays, and whites passing
graves of those they buried. They don't color prayer. They pray for today + everything.

Love first the color of the brackish waters you get your food from, the drake duckling
before it displays its iridescent head, day's first light before color, today + everything.

Before you give yourself a name, ask how you'd color a Jude, or Ambrose, or a darling.
Ask the color your feet make stitching the earth, ask what's this + today + everything.

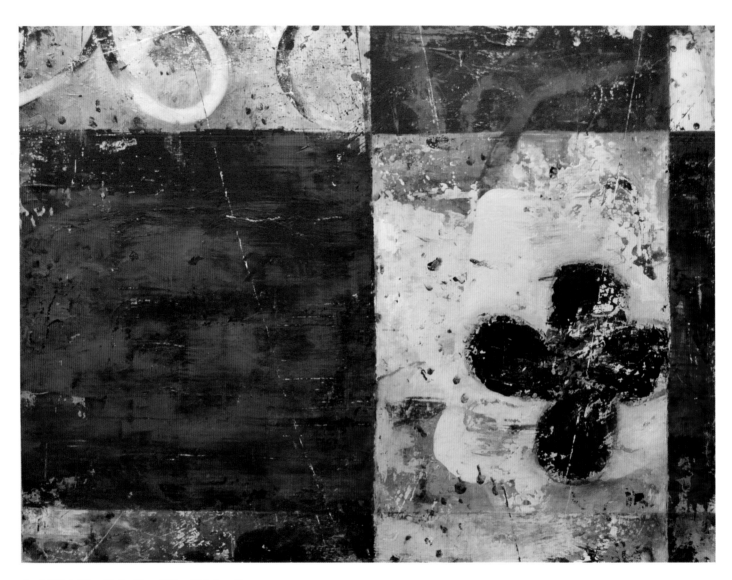

Look Who's Here To See You, 30" x 40," Acrylic on canvas

LOOK WHO'S HERE TO SEE YOU
for Diana Gingles

My son was ever present and then he was not there at all for years.
He showed up unexpectedly singing "look who's here to see you."

I woke from the dream he traveled in. We'd loved all those years
we foraged together, for food and for each other. I want to see you

when you're grown and have children of your own in a few years
I said, to know what of you will live in me and how I will see you

as some bridge between them and me. Some hours were like years,
some years like withered branches when I thought I'd never see you,

and then you were the catenary between then and now. This year's
ended with my name scored inside a song and I was here to see you.

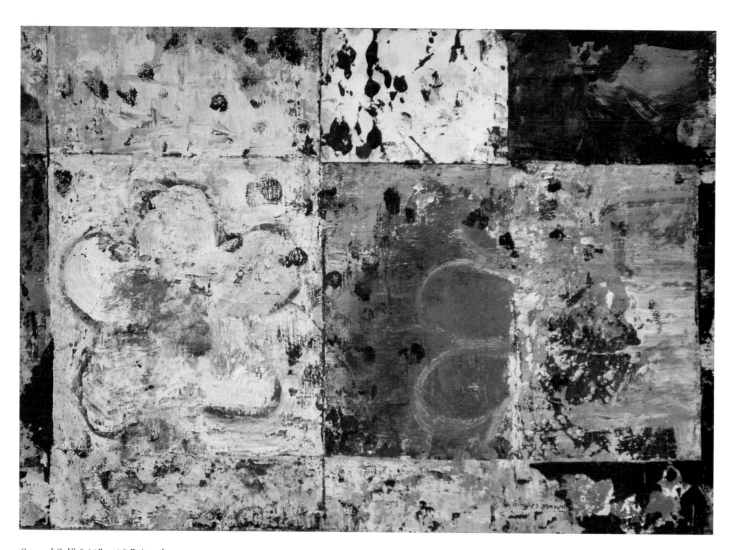

Second Self, 8 ¼" x 12," Acrylic on paper

SECOND SELF

Vermeer saw blue he fell in love with daily in the canals surrounding Delft,
a sky blue grayed by a city floating in a larger sea, this blue a second self.

The blue we see in those leaded windows he brings his models to is his
way to get right up next to what he wanted to be next to, another self.

That tempered blue he off set with letter or balance, blue in the apron
of a milkmaid pouring milk, it's all a way of finding ways to another self.

He liked to offset all the year-round cloudy blue with yellow or with gold.
Painting, ghazal, song, they're all portraits, one self seeking another self.

The Dutchman had more than a hand in all he did. Bill Gingles' fingerprints
are all over his *Second Self.* If you read this, read Bourg, another second self.

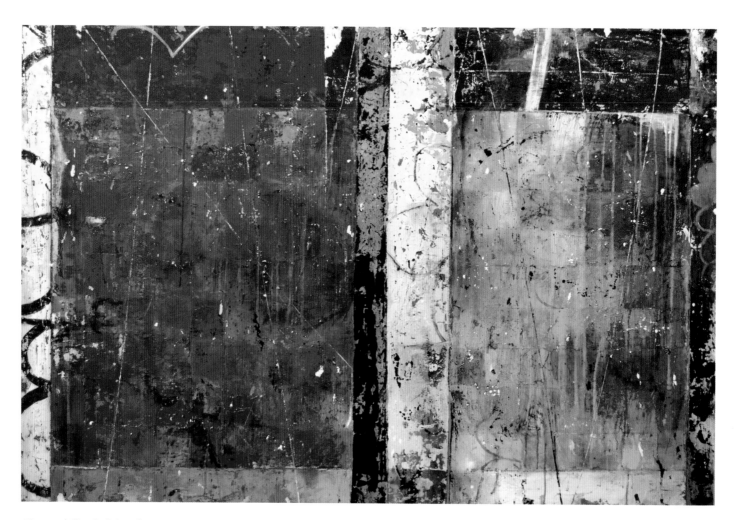

Harem, 40" x 60," Acrylic on canvas

HAREM

She planted lilies along the water channels in the compound. The arum
were her favorite, the spadix a nakedness no one saw inside the harem.

This place of colored veils and soft silks, of deep interiors, of smudged
lines and unyielding partitions, it is the place I dreamed in, my harem.

We lived with the prettiest boy who ever lived. We called him Miryam.
He came to souk, market, and bazaar. One day he was no longer harem.

Outside men cultivate roses in public gardens, isises, tulips, pittosporum,
and fritillaria, place them where someone can bring them into the harem.

The gates to our compounds are painted in our sacred colors, one blue
of sky, another green of fields. Women choose the colors in the harem.

Silk string netting is a screen she sees the outside world through. Karam
embroiders little purple and yellow squares inside her burka in her harem.

My old grandfather used to think his favorite whiskey was Harem Walker.
Jusqu'à sa belle-mère lui a dit, "C'est Hiram tu bois, imbécile, pas Harem."

We wash our clothes and those of the men and children too on stones
near the rushing waters. The women talking are bells inside the harem.

We are teachers and guides. No one knows how the works of Khayyam
got to us. Hidden secret verses, we take the tentmaker into the harem.

Then Umm Kulthum and Omar Sharif came floating in on lemon leaf,
flying in on a jasmine wind. Someone smuggled a radio into the harem.

Your father houses mystics. Your mother's maths prove the theorem.
You're a rhymed equation of their truths, that x that love is, in a harem.

She didn't know what to make of names here, or how to drive to Tarum.
Your mother turns to algebra, "everything outside harem is inside harem."

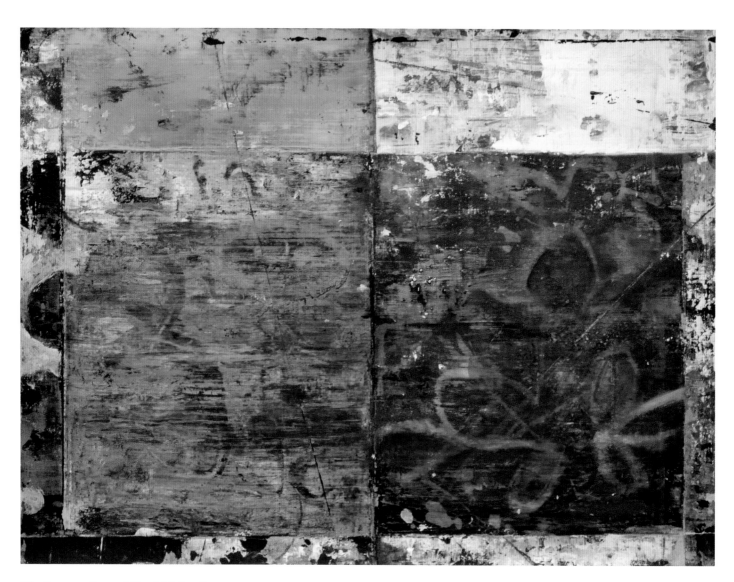

The Breeze at Dawn, 18" x 24," Acrylic on paper

THE BREEZE AT DAWN

Someone has cleared the table in the courtyard. Everyone has gone,
and yellow pollen from the oak tree is falling in the breeze at dawn.

Your mother worked to get you here on the chance you might breathe
the air she breathes. It is she who delivered you to the breeze at dawn.

She saw them beat you, in some corners she heard you called *maricón,*
someone brought the final news. Her heart stalled in the breeze at dawn.

All her choices were choices of charred remains, all flowers were flowers
covered in soot. She walks now. Something rooted in the breeze at dawn.

No one knows a thing about the morning they cornered Lorca in a cell,
or brought him into a yard, or whether time was the breeze that dawn.

We lived where we lived as untouchables. Then they called us gypsies.
We carry *gypsy* with us wherever we go, carry it in the breeze at dawn.

Your tongue went dry. You heard disquisitions of crows, cries of fawns.
Words worked their way back, you heard *migraré* in the breeze at dawn.

You fell from the arch your mother's ribcage made for you, your first home.
It was your first migration. Outside was something like the breeze at dawn.

We weave flowers from our mother's gardens into the cloths we make,
flowers blooming in the colored scarves we wear in the breeze at dawn.

How to translate *darling*, how to say Luma in another tongue, or Jude,
or Ambrose. What your name is hardly matters in the breeze at dawn.

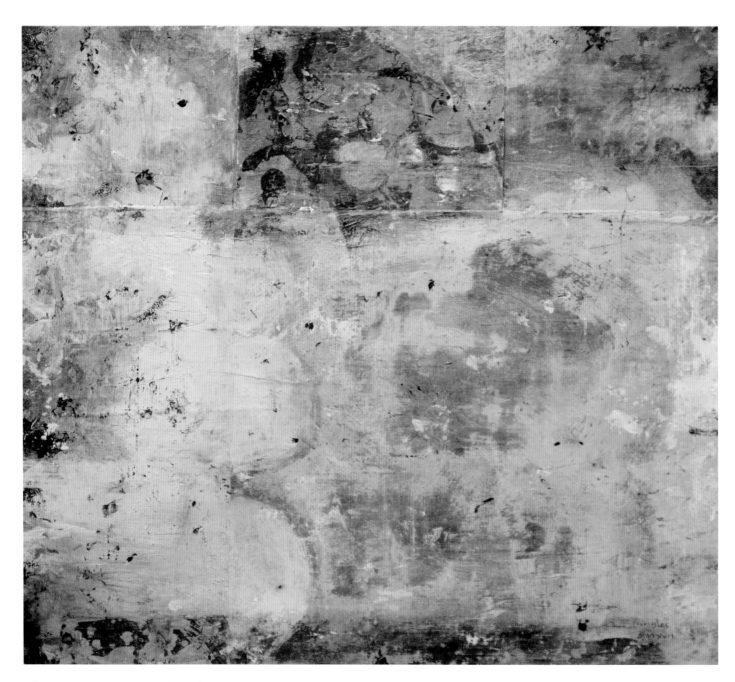

This Morning, 10 ¼" x 11 ¾," Acrylic on paper

THIS MORNING

for Ann Brewster Dobie

Already the dream of being guided unravels like so much shredded string.
Lines like beginning of flowers and a little red copse fade into this morning.

My friend says dreams are happenstance, random synapse flarings, nothing
like the little dramas we bring our therapists, says he dreamed this morning

a dream without figure, with no tag of narrative, nothing signifying anything
other than random energy. Stories begin with the possibility of this morning,

he says, time is the opening chord: a *dark and stormy night,* or a *Last evening.*
I don't know what he knows. I also don't know what to make of this morning,

I am moving into my friend's house and she still lives in it. She stands waving
from her driveway but we are not coming or going. It's Beckett this morning

she's reciting, a long Winnie monologue from *Happy Days.* Winnie's telling
husband Willie buried behind her, "Oh, this *is* a happy day." It's this morning

in some collage, she is speaking, little red trees through shells are sprouting
in the space where her car should be, says we won't need cars this morning.

You can see the horizon line in this dream. It's about 5/7th up and crawling
across the *mise en scène;* the yellow wash is the yellow wash of this morning.

She calls me by one of my names. I've always listened to her, I'm hearing
Beckett so clearly now. How could that not mean something this morning?

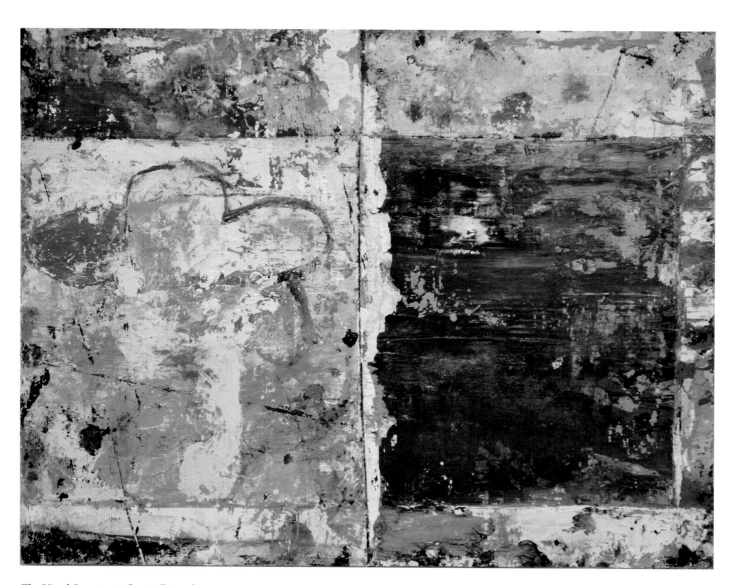

The Usual Surprise, 15" x 20," Acrylic on paper

THE USUAL SURPRISE

John the Baptist sings dark cisterned worlds. If called upon he'd still baptize.
He lived by roots, rags, and seizures, wrapped himself in the usual surprise.

The way maths work in paintings, geometric factor parading under the guise
of color, painters not wanting to show they're going after the usual surprise.

I've seen you in that dark square death holds us all in. An impastoed demise
thick as dough you lighten with blue hydrangeas, all yours the usual surprise.

The blue hydrangeas again, the rotting leaves, the rusted watering can, cries
of jays in gardens. You hedge your bets on another spring, the usual surprise.

You live at intersections, crosses and crossroads lead somewhere. If *It* dies,
its got fifty miles of elbow room on the other side. *It* is the usual surprise.

My mother called me by both my given names when I had done the inadvisable.
She counseled always against foolish repetition. Her tone was the usual surprise.

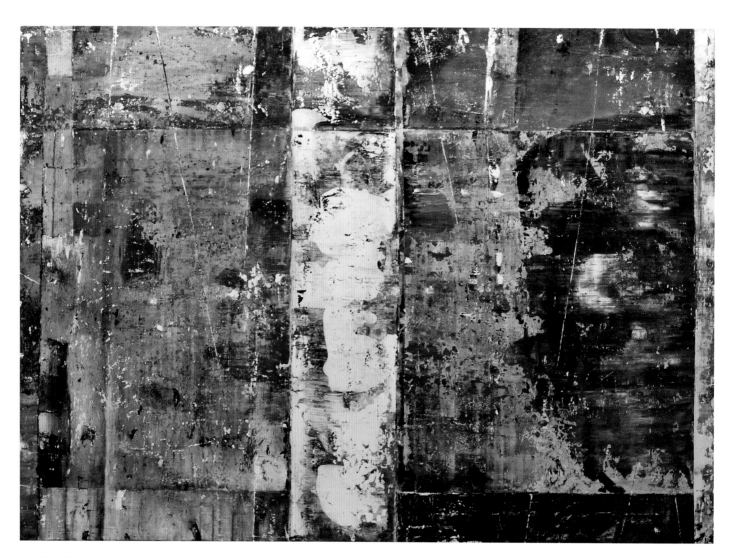

Riddle of Jars, 36" x 50," Acrylic on canvas

RIDDLE OF JARS

Now we mostly sing in bars, in cars, with Bruno Mars, with stars. We can parse
string, paintings, urges, chords, killings, praise. We are stored in a riddle of jars.

I'm Calli, oldest of them all. My father, as you might say, had a vested interest in
what I sang & how. He hooked up with my mother & here we are, a riddle of jars.

The Dutchman's draped me in a blue shawl, placed me near a leaded window,
crowned with blue leaves. What's with him anyway, his blues in riddles of jars?

When I sing someone will die but we'll all be better in the end. That spot of red
you cannot erase, or wash off, or ignore, I am jab, the toxin in the riddle of jars.

I was meant to please. I chased *cauchemars* from little Mozart's bed & I taught
Schönberg too as a child & in spite of all he might deny, I'm in his riddle of jars.

I play *kithara & lyre.* You play guitar. We're both driven by desire. White gingers
in summer can't undo you as I can, nor Django in September in his riddle of jars.

How we move matters. Ask Martha Graham, Ailey, DeMille, Duncan & Dunham.
Motion measures violet. Emerald, ruby & diamond are Stravinsky's riddle of jars.

Physics of fire might begin in constellations or in that interior heat when Voltaire
walked in the room. Call every love she loved true, call love *fire* in a riddle of jars.

My name blossoms on your tongue in any language. I sing pastures, savannas,
hill & field riddled with poppies. You stage your marriages in my riddle of jars.

They call me Polly in a beggar's opera but I go back so much further than that.
You can find me in sun choirs. I could be *maya* or *harem* inside a riddle of jars.

Our mother knows your name and mine too, can call names in any language.
She has what we call eidetic memory. She has the answer to the riddle of jars.

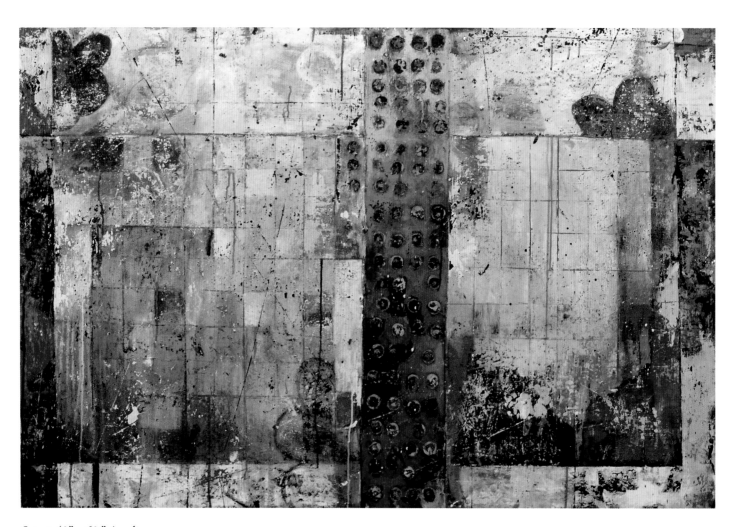

Satori, 40" x 60," Acrylic on canvas

SATORI

You are that restless bird your parents hadn't counted on. You are the mystery inside their lifelong pilgrimage. They remain at least one child away from satori.

Your mother meditates in the courtyard, travels to the blue of the morning glory she planted there to center practice. She is at least two shades away from satori.

Your father's hands are calloused, raw from those days he spends in the quarry. He prays prayers of rock and chisel. He is at least two stones away from satori.

When you go to sesshin, your biggest challenges are the others in the dormitory. They snore & make unholy noises. You are at least seven monks away from satori.

During morning meditation you try to deliver yourself from the march of history. Everything this morning is hit or miss. You're at least five wars away from satori.

How to see into one's true nature if one's true nature happens to be migratory? No one's counting 7s or 12s or just how many journeys you're away from satori.

Something sudden might happen, or it may seem to take forever. The inventory you keep won't tell you how long. Lhakthong Luma, name itself might be satori.

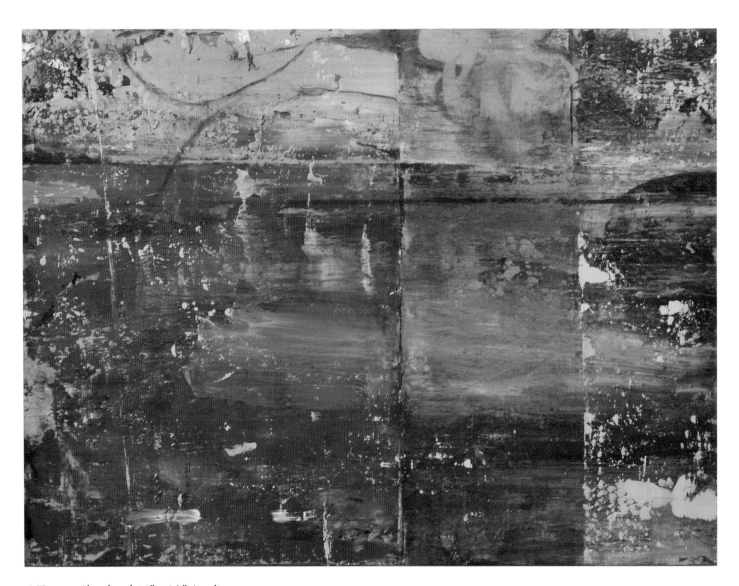

A Treasure Abandoned, 18" x 24," Acrylic on canvas

A TREASURE ABANDONED

To give control over to someone, or something other, to know how words expand and contract over time. Roots, branches, before and after, all part of a treasure abandoned.

My sister was raped last night by too many soldiers to count. They laughed, pranced, and smoked afterwards, then slept. That place she once called home, a treasure abandoned.

My grandmother could not take her baking stone, or her combs, or her pots, pans, and the china cup she always drank her strong coffees from. A cup, a treasure abandoned.

We put on layers of clothes, hid money in the folds. We sewed necklace strands and small gold coins in hems of skirts. The bolt of green silk we left, a treasure abandoned.

My grandfather the goldsmith made the gate in the courtyard. He planned it and hammered its metal, painted it the green of faith, our gate, a treasure abandoned.

The thin blue pocketbook my mother loved, the one she took out, fanned with and flaunted in the marketplace. She did not miss it, then she did, a treasure abandoned.

The raped girl you think is not your sister is, your grandfather with no hammer and no plans for gates, your purseless and stoneless mothers, all treasures abandoned.

The seas of ever-changing blues and greens you swam in, the pink and yellow sands you played on, red roof tiles you could see from the water, all treasures abandoned.

You walk now without the things you left behind. You travel with a strange name and try to love that old familiar in your new name, your old name, a treasure abandoned.

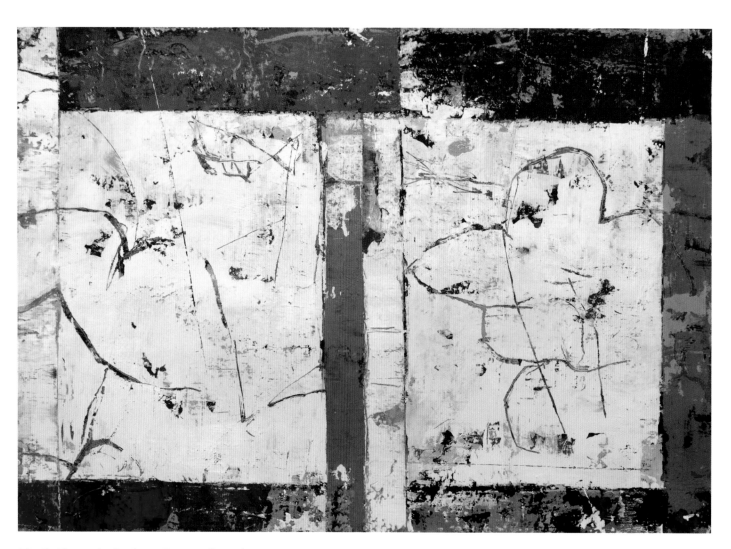

The Goddess in the Garden, 21" x 29 ¾," Acrylic on paper

THE GODDESS IN THE GARDEN
for Malak Lahham

It seems we are always walking toward water, the Adriatic, the Aegean, a river Jordan,
a river in the Americas. Before we walk one of us will dig up the goddess in the garden.

We will take her with us. Classical Arabs loved lines but hardly ever let them harden
into image. Lines extended into lines lead us to the heart of the goddess in the garden.

They lived inside this moving into something you are so afraid of. This need to cordon
off and sequester they left to the Arabists who barely know the goddess in the garden.

When my mother first hennaed my hands and feet, she copied the design in the burden
we were leaving and would never see again. She saw in them the goddess in the garden.

My mother told me my feet would embroider the earth I walked upon. We are done
with one idea of home she said. She'd been talking lately to the goddess in the garden.

She said the attar of roses came to Juan Diego in a miracle falling on him like a curtain.
What had been home was home no more. He moved in with the goddess in the garden.

In India, in Pakistan, wherever the Roma travel, wherever you might see a purple martin
flying, that place can be home she says. Her new best friend is the goddess in the garden.

She carries her in the folds of the skirt she wears closest to her skin. As sweet as lark song,
she says, this goddess's voice. She says she sings of olive trees, the goddess in the garden.

She says all the Darlings in the world who make poems have lots to learn from Lhakthong
Luma. Find cartographers new jobs she says, let them work for the goddess in the garden.

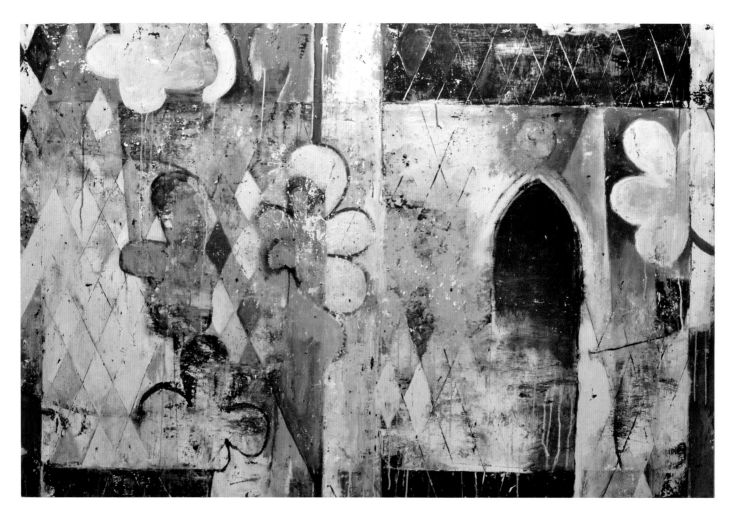

Six Visitors, 46" x 70," Acrylic on paper

SIX VISITORS

That child they pulled her from was her child lying beached next to the blue water at Zanzabar.
Her flower stall at *Ospedale degli Innocenti* is no consolation. She's less than one in six visitors.

Remnant of whatever is above the arch here could have been set by one of the Della Robbias,
flower, peeling plaster, sign signifying something we know no more. I'm the first of six visitors.

The elder they walked with here told them never to walk on the diagonal, said all inquisitors
like straight lines, immigrants can't walk a cut-in-the-bias walk, not two, or sixty, or six visitors.

We made clothes with whatever we could take with us. We cut cloth on the bias for strength.
We looked like we are walking from someone's idea of circuses. I am the second of six visitors.

The elder said the places we are going to cannot see us as anything but visitors. Their histories
will not allow it. We carry the mongrel mind in us. They think numbers. For now, it's six visitors.

Water seeped from plaster in the buildings we passed along the way. We were always thirsty.
Even what we knew were mirages gave us comfort. I am third, the dry reed of the six visitors.

When we left that dark pointed arch in the courtyard my mother had on at least six chādors.
I walked behind, under her hems green silk, sardonyx sheer, persimmon laces like six visitors.

I often wanted to enter the flowers in the field. I did not know how. I want to sleep forever
in caves, under brush. I did not want to come out of the dark. I am the fourth of six visitors.

Sands in late afternoon turn dusty pink, sand like sky. Between earth and sky no signatures
we can see, no signs of anything. We will walk. Our mothers will tell us stories of six visitors.

At school I'd learned that everything measures differently at the edges of known space.
I ask the fourth visitor of theories of different measures. I am the fifth of the six visitors.

At first we thought we were seeing Bedouins kneeling in midday prayer, those sycamores
filled with figs and shade, figs and shade for a thousand and for a hundred and six visitors.

I've heard the stories of the old desert fathers. I dream them dancing in the monsoon rain,
raising their faces to falling water. I dream them at waterfalls. I am sixth of the six visitors.

They called us by names we didn't know. We lost names crossing fences, leaving borders.
My new name sounded like leaded glass. What they called me housed at least six visitors.

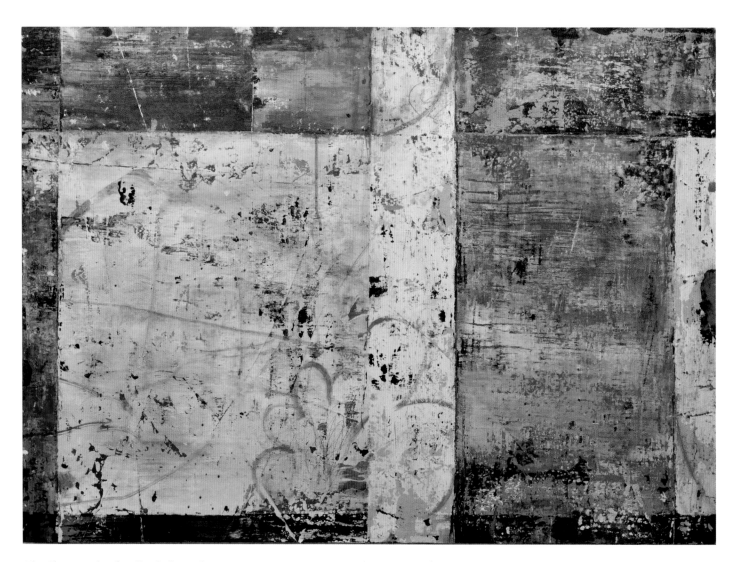

The Clearing Ahead, 30" x 40," Acrylic on canvas

THE CLEARING AHEAD
for Michelle Vallot

She knew she'd lighted the oven for the last time. She loved woodsmoke, the smell of it in bread.
She looked out at her morning glories climbing the courtyard wall, blues from the clearing ahead.

You were least expecting anything unusual. Inside the chatter at the fountain was your beloved.
You had let go of all you thought you owned, robe, book, bead, prayer, all for the clearing ahead.

A man and woman stop walking. They dance because they have to. They have nothing to dread,
he raises his hat, she shows him the soft flesh of her upper arm. They dance the clearing ahead.

Grandmother moved in with us. She was not immigrant. From her husband's one book she read
us stories he wrote in a book the color of autumn. He's the gold wanderer in the clearing ahead.

You see that picture with "Doktor Jazz" at La Cigale? Django's mangled hand will put "*Nuages*"
into Nazi beds tonight. Who's Gypsy here? What jungle music? What color the clearing ahead?

They say in the caravan there are Middle Easterners. East of what Middle? We are to be afraid
they say. They say look to the inside. Inside we have each other we say, and the clearing ahead.

You moved into me without asking. Your whole body shuddered when you came. I never said
I'm Rabia. We had no common tongue. After I bathed you, I walked you to the clearing ahead.

I found my son faceup in the shallows of *Baie Sainte-Marie*, his skin the color of slate or lead.
We fought side by side, walked side by side. I still hear him calling me from the clearing ahead.

I'm Bourque here, or Bourg. I came with Thibodeaux, Levy, Latiolais, Castille, Dargin, Daigle,
Vallot, Boustany, Richard, Falcon, Arceneaux, Porche, cartographers all for the clearing ahead.

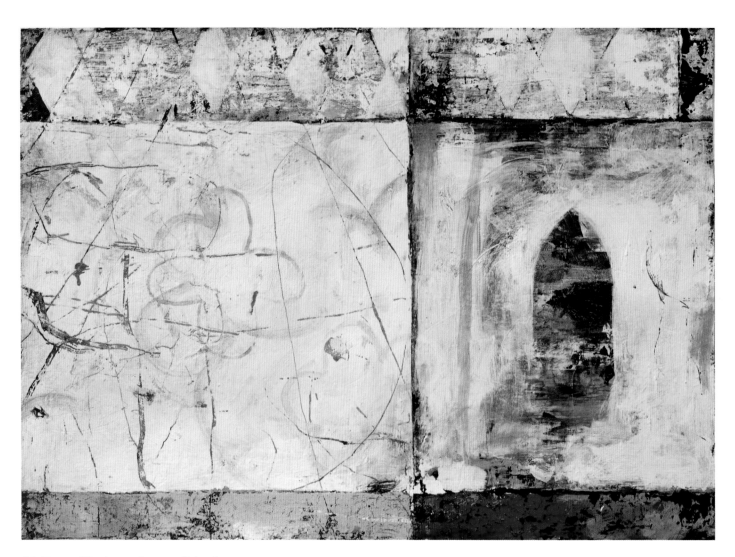

My Foreign Window, 21" x 29 ¾," Acrylic on paper

MY FOREIGN WINDOW

They burned our houses and fields in Acadie, burned us out of Myanmar. We are Rohingya
wherever we are, we are Cadien. Every window now in this new land is my foreign window.

Throughout this house is uncertainty and untimely death and unbaptized souls in limbo.
The theater is made for you. You will enter through that dark arch I call my foreign window.

At Grand Pré *Le Grande Derangement* began in a church. After Lamumba we see Pauline Opango
walking bare-breasted in Leopoldville. She baptizes this grief. She names it My Foreign Window.

Enter the scene where you can. Even the faint flowers are standing before you all akimbo.
They too are passageways and entrances I made just for you, each one my foreign window

leading you away from what you call home, each leading you to the unaccompanied cello
you are or will become if you cross the threshold where I am waiting in my foreign window.

Boudreaux, Jagneaux, Begneaud, Comeaux, Moreau, Domengeaux, like straw in a windrow,
Thibodeaux, Vallot, Fontenot, Romero, Vautrot, a line of kin ending at my foreign window.

When Bonnard painted windows you could count on lush green beyond, some lime willow
winnowed, a patch of blue sky here and there, unlikely companions to my foreign window.

Maybe it was the tattered clothing that scared them, the oddness of patchworked sorrow,
the demon horsemen or the smart-mouth joy uttered every time I saw my foreign window.

The darkness in this doorway is darkness set in the clouds. On the other side is no sparrow
of doom. To some monks nothing is sacred emptiness, sparrow song of my foreign window.

Who can argue with Matisse's *Open Window, Collioure?* Walls blue-green, fuchsia, the narrow
harbor view, the blue boats, flowers filling the spaces he could have called my foreign window.

I am bloodstone and carnelian and sardonyx, wander with Jews and gypsies in vast yellow
deserts. We are always thirsty, always hungry. Every desert window is my foreign window.

In Edward Hopper's *Rooms by the Sea*, white rhymes freeze yesterday, today, tomorrow.
My blue sea, he says, *my sky, my white walls, my red seat, my light in my foreign window.*

My first move to something else or someplace else started when I fell through the narrow
passage my mother made for me. She held me until I could become my own foreign window.

Only my mother called me by both my names. Her perturbations made her throat a hollow
core. *Darrell Jude!* How could I be other than who I was, not love my own foreign window?

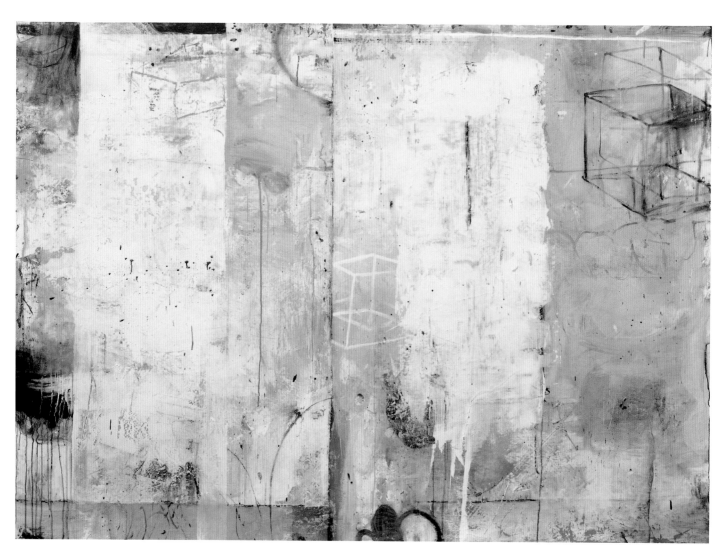

Place of the First Beginning, 60" x 84," Acrylic on canvas

PLACE OF THE FIRST BEGINNING

Imagine yourself before you know the names of things. You can hear the aria your mother is singing, singing you couldn't hear before now. Water you swim in trembles in this place of the first beginning.

Kateri Tekakwitha was Algonquin-Mohawk. In her native tongue Tekakwitha is *Bumps Into Things*. She braided her name to Catherine's, immigrated to Place of Miracles, Place of the First Beginning.

In the afterlife trifoil and quatrefoil and cinqefoil or how many lotus in a dozen might lose all meaning. How numbers mean or rates of quanta radiation, time variates time in the place of the first beginning.

It's sunset at the foot of Heart Mountain. You're somewhere between Powell and Cody Wyoming. The buffalo graze in measures of time you will never know, graze the place of the first beginning.

Your mother and your mother's mother were the first immigrants to lay claim on you. Your finning from their beating hearts was you finning as they had finned to reach a place of the first beginning.

My friend Bill paints boxes in boxes, white boxes, red boxes, paints walls with measured meaning, paints operas only he can hear, amphoras, parallelograms, letters to a place of the first beginning.

Find those skies where dark clouds send their rains into showers of gold, where ramblers are tinning pots and tending horses with travelers, bend to flowers at your feet, sing place of the first beginning.

The blue boat in the upper register marks a passage to your blue symphony in blue seas brimming to take you to another shore. Geography is often no consolation nor is place of the first beginning.

When she was blind, she could still see her Pedernal lifting blueness from the narrow mesa rising like a shadowy sun. She made up a story of a bargain with God, about place of the first beginning.

The Mediterranean makes a big circle. Cruise ship dreams, boats of St. Tropez dreams skimming past cargo ships. In rubber rafts someone's paid with his life for this place of the first beginning.

Shostakovich scored the difference between being moving into a score and the siege of finishing. *Everyone feared everyone else … sorrow … suffocated us,* then came place of the first beginning.

Métis is written in my cheekbones. I've been told where I come from, but I will never hear the ring inside my Mi'kmaq name. Could I be both Algonquin and French in my Place of the First Beginning?

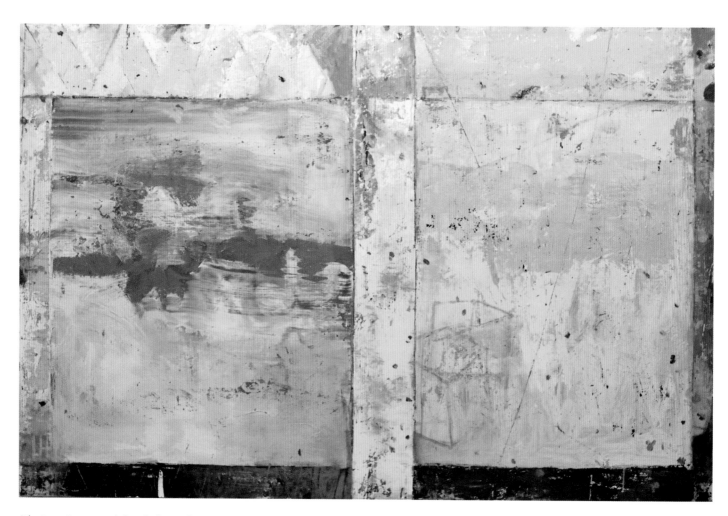

The Last Overture, 40" x 60," Acrylic on canvas

THE LAST OVERTURE

We're way too close to that land we once called home. We gather at evening time in the hush arbors. "Walk Together Children" and "Were You There" are our journey songs, prelude to the last overture.

Between the home you knew as home and the one you're on the road walking to, you're some slur holding yourself together. Your notation's a bridge of sorts, a mark in the staff in the last overture.

What you are trying to walk away from are those who teethed on words like prefecture and ligature. What you're hearing are the white symphonics from the other side, golden rain in the last overture.

We write tone poems, operas, epistles to you. On boxcar sides day-glo orange was our signature. You saw that we had been there, that we'd defiled something. You never heard the last overture.

If Stalin sent us Akhmatova, we'd have taken her. Baryshnikov can dance among cranes in a pasture at White Oak. Balanchine, Einstein, Levi Strauss, Albright, Pulitzer, Pei, all notes in the last overture.

We've grown used to Harlequin's diamond-patterned dress. He doesn't have to talk. He's that pure. We are afraid of those who walk to us in rags, even if it's all they have to offer to the last overture.

It's what we have to write on, your walls, your never-ending signage of how good you are, your lure to a paradise you locked the gates to. What I must tell, you will not hear, silence as the last overture.

What held us together I thought was surely covenant. You reworked the contract toward indenture. Your border held when you needed it to, but your sometime slaves will not sing in the last overture.

You see columns and walls that will protect you from us. We're coded in staves in an entablature you will not read. You are pickers, choosers, cannot hear your own phrasings in the last overture.

Shostakovich and Mozart, Copeland and Stravinsky, Ravel and Satie, they all knew the treasure in what's to come. Beethoven, Glass, Olivier Messiaen's *Quatour,* embraced in the last overture.

We mostly walked at night. Every track was black as pitch. We looked everywhere for aperture. We sang "Mary, Did You Know?" We recited poems by Rabia. We waited for the last overture.

What if in *pour la fin du temps* we hear the names of all those who've walked to some other shore: hear then all the above, hear names we call ourselves, hear all we call beloved in the last overture.

ACKNOWLEDGMENTS

Every poet I read is a teacher. Every teacher I've studied with is in these poems. Every novel or short story or memoir or enlivened conversation is for me template for a poem. I have worked with the best of the best: my fellow Louisiana laureates, my friend and colleague Ernest J. Gaines whose language goes right to poetry again and again in his stories. I am especially vulnerable before the works of painters and storytellers and composers. I have been lucky enough to work closely, and even collaborate on rare occasion, with the likes Barry J. Ancelet, Sheryl St. Germain, Greg Guirard, John Gery, John Hathorn, George Marks, Patrice Melnick, Lynda Frese, Sidney Creaghan, Vaughan Baker, Gloria Fiero, and Mathé Allain. I have been shaped by the best teachers of the poem and of the story: Van K. Brock, David Kirby, Ann Brewster Dobie. I cannot even begin to articulate or understand the art relationship I have with my wife Karen, who teaches me more about being an artist than anyone I know. She is an in-the-trenches artist who balances the intuitive with the mystical sublime better than anyone I know. Her ability to keep her work inside the carpentry of making until it is ready for release is perhaps the one best practice she's taught me.

But with this work in particular, there are two artists who are co-creators of this sequence of poems: Faisal Mohyuddin and Bill Gingles.

Faisal reintroduced me to the *ghazal,* a form I read and admired for years, a form I was long intimidated by, mostly through reading the masterworks of the ancients like Rumi and Hafiz and contemporary poets who adapted, translated, and transfigured the form for their own articulation of the form, not the least of which is my friend, James McDowell. In 2018, when Faisal and I were working on another project entirely, I was introduced to his *The Displaced Children of Displaced Children,* 2017 winner of the Sexton Prize in Poetry, and the ghazals in the work. In a brief exchange he gave me the basic armature for the form and his practice of it, and he guided me through the first ghazal that I dared let anyone see. As I took this Faisal lesson into this *migraré* sequence, I began to experiment with the possible applications of the form to address contemporary issues and to use the similar amatory fervor of the ancients to address *immigration.* I wanted to explore how the corollaries of *I will move* and the oppositional corollaries of *to move into* bring forth identities we can live with and live through, how we are drawn to saving ourselves at whatever cost the saving involves, how the lures of being are as necessary as they are mystical, and finally how *to move into* is as natural and as primal as anything we experience as humans.

This is my third book with Bill Gingles. In each he's allowed me to use his paintings as springboards to poems. He releases the paintings fully and freely with the only compensation being the outcome of the poem or the sequence of poems. *Where I Waited* (Yellow Flag Press, 2016) and *From the Other Side: Henriette Delille* (Yellow Flag Press, 2109), were only possible because of the generosity of the artist, as is this book. In each of these books I try to extend the idea of *ekphrasis.* In each of the poems I incorporate the lexical tag the title is to the content, tone, and theme of the poem I am trying to "key" to the painting, each poem a conflation of painting, music, and poem. I know I am drawn to the works of this Shreveport, Louisiana abstract expressionist's paintings because they are for me as mysterious and as essential as poems are. In Bill's work I am given a theater of color, form, line, composition, images, and icons. The works invite a different ekphrastic response than narrative control invited by realism, figurative paintings, paintings with historical or religious agendas, paintings that are bound by the easily recognizable images we tell ourselves are the real things of the real world.

NOTES ON POEMS

"The Bracelet Under the Oaks in Sanjay and Kevin's Yard"

I was reading Faisal Mohyuddin's *The Displaced Children of Displaced Children* for the first time, being reacquainted with the ghazal as a form. The "yard" is in Arnaudville, at the home of Sanjay Maharaj and Kevin Robin. The occasion was the arrival of the Immigration Team from Narrative 4's field excursions into various parts of Louisiana as part of N4's 2018 Summit agenda: the vanishing coastlands, youth incarceration centers in New Orleans, faith centers in New Orleans, the Whitney Plantation Museum on the River Road devoted to slavery in the southern United States, and to the rural countryside holding small Louisiana towns. In Arnaudville we were exploring immigration experiences that fall outside the usual ideas about migrants, expulsions, migrations, and the colonial mind and colonial vocabularies related to the "immigration" ideas and experiences. The N4 storytellers from all over the world were greeted by the dancers and musicians of the Canneci N'de band of Lipan Apache in a dance-drumming-singing ritual braiding the "outsiders" into a ceremonial welcome. The Lipan Apache have been erased from the history books and their descendants have been variously described as: colored, negro, black, mulatto, metis, griffe, Creole, white, sauvage, Mexican, and in some cases "No Tribe." This variant of the ghazal launched the *migraré* project.

The welcoming group from the Canneci N'de band of the Lipan Apache singers and drummers: Chief Cougar Goodbear, Edgar Bush, Daniel Guidry; dancers: Cidney Guidry, Lou Ann Moses, Agnes Guidry, Alfreda Mathieu.

Team Immigration Narrative 4: Felice Bell, New York, New York, USA; Darrell Bourque, Louisiana, USA; Lisa Consiglio, New York, New York, USA; Bayard Hollins, Ojai, California, USA; Jackson Hollins, Ojai, California, USA; Karen Hollins, Ojai, California, USA; Samantha Hollins, Ojai, California, USA; Lily Khoury, Nazareth, Israel; Malak Lahham, Nazareth, Israel; Hillary Wells, Boston, Massachusetts, USA; Gentian "Genti" Limani, Newton, Connecticut, USA; Faisal Mohyuddin, Chicago, Illinois, USA; Colum McCann, Ireland/New York, New York, USA; Alex McCarthy, Limerick, Ireland; Michael McRay, Nashville, Tennessee, USA; Rob Spillman, New York, New York, USA; Leah Siegel, New York, New York, USA.

"Division Stream"

My great grandmother, Elmire David Thibodeaux, did not speak English and refused to learn it.

"A Note from the Waterside"

One of the earliest recordings of Herbert Buffrum's "Fifty Miles of Elbow Room" was by Reverend F. W. McGee. It is McGee's version that DeMent attributes her version of the song to. Blessed Hahn is *Thich Nhat Hanh*.

"Maya"

The tillerman is, of course, Cat Stevens. Dolly is Dolly Parton.

"Event Boundary"

Desire is Desire Street in New Orleans.

"Every Time"

The classic Beatles' song "Hey Jude" evolved from "Hey Jules," a song Paul McCartney wrote for John Lennon's son Julian during his parents' divorce.

"Sun Choir"

Christ the King Church of Bellevue, Louisiana, is a rural, historic African American Catholic church and part of the Parish of St. Charles Borromeo of Grand Coteau, Louisiana, a Jesuit ministry. It was founded in the late 1930s by Father Joseph Cornelius Thensted S.J. and eventually staffed by the Sisters of the Holy Family, a New Orleans order of teaching nuns founded by the Venerable Henriette Delille (1812–1862). The church is part of a complex that once included a school and a convent where African American and Creole children received their education from the '30s to the '60s, when they were not allowed to attend public schools in the parish. The complex no longer functions as a school or a convent, but is an important community center not only for the rural population of the area but families that come "home" regularly to the sacred place from Virginia, the Caribbean, Africa, California, Houston, Port Arthur, Beaumont, and Lake Charles. The songs referenced in the poem are gospel songs sung at services my wife and I attend as "new" parishioners. Brother Wilfred is Wilfred Joseph, the bass voice in the choir. Autherine Christman is one of the elders in the church who often dances to the music. Her sister, Virginia Pierre, who drives Autherine to services on Sundays, is a former mayor of Grand Coteau and sings in the choir. While James Stephen Joubert is clearly the music director and accompanist, Betty Malbrough is a major spirit guide in the choir, in the congregation, and in the community.

"The Same Story"

Charles Bolden is Charles Joseph "Buddy" Bolden (1887–1931), the famed cornetist of New Orleans ragtime (jass) music preceding what we now call jazz. His final "migration" was from the streets and dancehalls of New Orleans to the Louisiana State Insane Asylum in Jackson, Louisiana, where he spent the last 20+ years of his life.

"Today + Everything"

A Burial at Ornans (10' 4" x 21' 8"), 1849–50, by Gustave Courbet is at the Musée d'Orsay.

Crawfish is a key figure in the creation stories of the Native peoples of the Chitimacha Tribe of Louisiana, the only recognized Louisiana Native tribe to still occupy a portion of their aboriginal homeland. The tribe presently maintains a reservation near Charenton in St. Mary Parish, Louisiana. The original tribal land extended from Lake Pontchartrain to Vermilion Bay.

"Harem"

Jusqu'à sa belle-mère a dit, "C'est Hiram tu bois, imbecile, pas Harem"—Until his mother-in-law told him, "It's Hiram you drink, fool, not Harem."

Omar Khayyam (1048–1131), Persian mathematician, astronomer, and poet.

Umm Kulthum (1898–1971), the internationally renowned Egyptian singer, songwriter, film actress, and national heroine—"the voice of Egypt." She figures largely in the ballad "Omar Sharif" in the film *The Band's Visit*.

"The Breeze at Dawn"

Frederico Garcia Lorca's full name was Frederico del Sagrado Corazón de Jesus, Spanish poet, playwright, and theater director; author of *Gypsy Ballads*, *Blood Wedding*, and *The House of Bernarda Alba*. Born June 5, 1898, he is believed to have been murdered by Fascist forces on August 18/19, 1936.

"Riddle of Jars"

cauchemar (nightmare)

Django Reinhardt (1910–1953) was the stage name of Jean Reinhardt, Belgian born Romani-French jazz guitarist.

Gabrielle Émilie Le Tonnelier de Breteuil, Marquise du Châtelet, Voltaire's mistress and great love, was a natural philosopher, author, mathematician, translator of the still standard French edition of Isaac Newton's *Principia*, and physicist whose

1737 *Dissertation sur la nature et la propagation du feu* predates what we now know as infrared radiation.

"The Goddess in the Garden"

An Arabist is someone usually from outside the Arab world who studies Arabic culture.

Juan Diego (1474–1548) is Saint Juan Diego Cuauhtlatoatzin, a Mexican native and the first Roman Catholic indigenous saint from the Americas.

"The Clearing Ahead"

"Doktor Jazz" is the clandestine jazz-loving German Luftwaffe officer Dietrich Schulz-Köhn.

Rabia Basri (713–801) often known as Rabia of Basra is Rābi'a al-'Adawiyya al-Qaysiyya, a Muslim saint and Sufi mystic.

The point of land off *Baie Sainte-Marie* in southwest of Nova Scotia would eventually become known as *Pointe-de-l'Eglise*, or Church Point. The settlement became a center of Acadian culture and education. It is the home of Sainte Anne University. French Acadie in Nova Scotia was the birth place of Joseph Beausoleil Broussard, a fierce resistance fighter against British domination for nearly ten years. He, his brother Alexandre, and Joseph Guilbeau led the 1765 migration of the Acadians to Louisiana.

"My Foreign Window"

On September 5, 1755, 418 Acadian men and boys reported to the parish church at Grand Pré. French interpreter British Lt. Col. John Winslow told them that they and their families were to be deported: "*your Lands and Tenements, Cattle of all Kinds and Live Stock of all Sorts are Forfeited to the Crown with all your Effects Saving your money and Household Goods and you your Selves to be removed from this … Province.*" By Christmas of that year over 600 Acadians from 98 families were deported to the Anglo-American colonies, thus beginning the ten-year expulsion of the Acadians from Acadie in Nova Scotia, a region they had lived and prospered in since the early 1600s. Many found their way back to France, to the

Caribbean, and into the American colonies where they often lived marginalized. The largest re-settlement in the Americas was in Louisiana.

The flight of the Rohingya, a Muslim ethnic minority, from persecution in Myanmar is one of the latest examples of migration crisis. In 2015, the mass migration of these "boat people," fled into neighboring Bangladesh. The ethnic cleansing of these people continue to this day.

Pauline Onosamba Opango Lumumba (1937–2014) walked into her grief bare-breasted after her husband Patrice Lumumba's assassination (1961). Her walk in the streets of Leopoldville (now Kinsasha) was a protest against the brutal murder of Lumumba, a fierce fighter for Congolese independence and the first elected Prime Minister when Belgium granted the Congo independence after nearly one hundred years of colonial rule. Belgium later accepted "moral responsibility" for the assassination, widely regarded as a Western plot to disempower an African leader with a socialist ideology and agenda. She was with him when he was arrested and beaten mercilessly. He was later dragged away by the agents who killed him, then buried him, exhumed his body, and poured acid on the body. Her husband's mutilated body was never handed over to her and she was not allowed to visit his grave. She was forced to seek refuge in a camp built by the United Nations for political refugees. In the UPI photograph showing the twenty-four-year-old, bare-breasted widow, the caption reads "Lamumba's Mourning Widow in Léopoldville," along with the sub-caption "Gone were the Paris frocks."

Fellow Louisiana laureate Brenda Marie Osbey's tribute to Pauline Lumumba is her 2018 poem "On Contemplating the Breasts of Pauline Lumumba," which carries an epigraph from the Robert Hayden poem "Frederick Douglass": "*When is it finally ours … this beautiful and terrible thing.…*"

"Place of the First Beginning"

Kateri Tekakwitha (1656–1680). Tekakwitha was baptized as Catherine in honor of St. Catherine of Siena and is generally known as the Lily of the Mohawks. An Algonquin-Mohawk, she is the first First Nation American canonized a saint by the Roman Catholic Church.

Heart Mountain is visible from the Heart Mountain War Relocation Center (1942–1945), one of the ten concentration camps for the internment of Japanese Americans during World War II. The camp held a total of 13, 997 over a three-year period.

The reference to the painter Bill is to Shreveport, Louisiana, abstract expressionist artist Bill Gingles, painter of the works these poems are keyed to.

The "she" in the Pedernal couplet is Georgia O'Keeffe. She liked to tell the story that God told her that if she painted her beloved Pedernal often enough, it would be hers. She is for me a symbol of the migrant-within-ones-own-country. She "moved about" until she found her spiritual and artistic homeland, a homeland across the country from her husband, photographer and modern art promoter, Alfred Stieglitz, who showed and supported her work from his New York gallery and connections.

The "Mediterranean" couplet references the many present day refugees from Africa into Europe, often perishing as "dealers" take them across the sea in overcrowded and un-seaworthy crafts.

Dimitri Shostakovich (1906–1975), composed his *Seventh Symphony*, his great wartime composition, during the Siege of Leningrad. The Leningrad Premiere by Leningrad's Radio Orchestra forced conductor Karl Eliasberg to recruit anyone who could play an instrument to perform the symphony, as the orchestra had only fourteen members left.

The Mi'kmaq were the first inhabitants of the land in the present-day Canadian Maritimes that the French moved into and called *Acadie*. The Mi'kmaq call the place *Cadie,* land of plenty. They are the First Nations people that the Acadians allied and lived with and intermarried before the Expulsion of the Acadians in the mid-1700s. It is not unusual to find traces and more of First Nation DNA in Louisiana Cajuns and other descendants of the Acadians the world over.

"The Last Overture"

Hush arbors and brush arbors are described in Barbara A. Holmes's *Joy Unspeakable: Contemplative Practices of the Black Church.* These were the secret meeting places of slaves, and newly freed slaves: "Deep in the hollows, under dense brush, the contemplatives gathered. They cleared soft places in the dirt so they could kneel in comfort during the long prayers and songs. Sometimes there would be a large washpot or kettle in the center of the gathering to catch the sounds of the pleas. As the spirits inspired ecstatic responses, folks worried that someone would hear so they would sing into the pot to catch the voice before the overseers [or bounty hunters] heard." p 59.

Anna Akhmatova (Anna Andreyevna Gorenko, 1889–1966) was the great Russian poet who was held by Joseph Stalin in the 900-day Siege of Leningrad and then moved first to Chistopol and later to Uzbekistan by his order because of her importance to literature. Other artists, musicians, dancers, and composers, Shostokavich among them, were also moved out of the city.

In the Stalin-Akhmatova couplet, the names of all the others are names of immigrants to the United States who made immeasurable contributions to world culture, immigrants as varied as the first manufacturer of riveted blue jeans to Madeleine Albright, the first female Secretary of State in U.S. history.

The White Oak Plantation near Jacksonville, Florida, is the animal preservation and land plantation site owned by Howard Gillman. He built dance studios there that became an important place to workshop emerging works by the world's leading choreographers. Mikhail Baryshnikov and Mark Morris took their name, White Oak Dance Project, from work done there for the touring arm of the Baryshnikov Dance Foundation.

Quatuor pour la fin du temps (Quartet for the End of Time) by Olivier Messiaen (Olivier Eugène Prosper Charles Messiaen, 1908–1992) is a quartet for clarinet, violin, cello, and piano. The French composer wrote the piece while a prisoner of war at Stalag VIII-A in Görlitz, Germany and it was first performed by him and his fellow prisoners, Étienne Pasquier, Jean Le Boulaire, and Henri Akoka on January 15, 1941, at the prison camp.

Detail from *High-level Goings-on,* 54" x 44," Acrylic on canvas